Contents

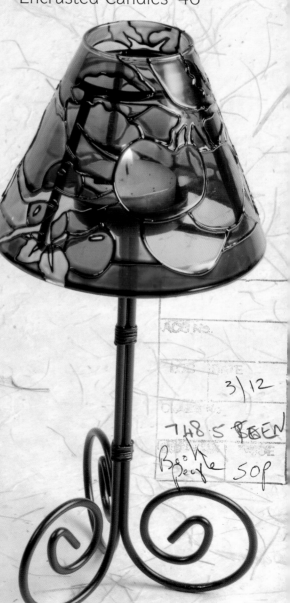

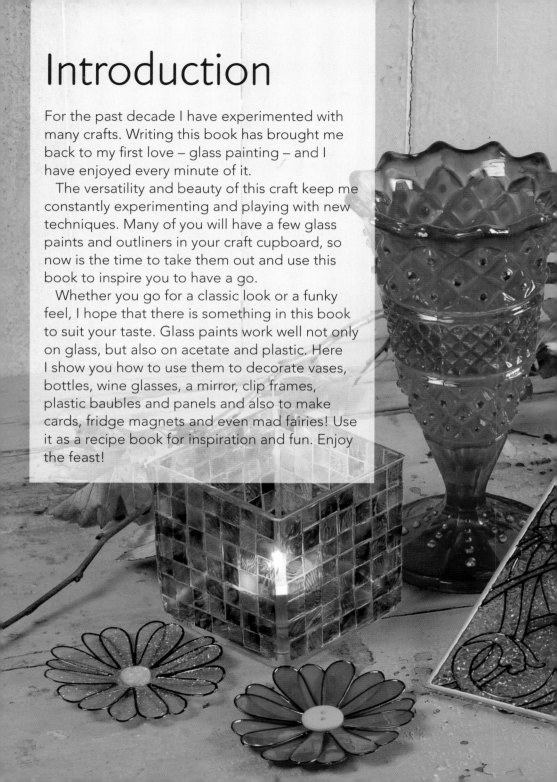

Introduction

For the past decade I have experimented with many crafts. Writing this book has brought me back to my first love – glass painting – and I have enjoyed every minute of it.

The versatility and beauty of this craft keep me constantly experimenting and playing with new techniques. Many of you will have a few glass paints and outliners in your craft cupboard, so now is the time to take them out and use this book to inspire you to have a go.

Whether you go for a classic look or a funky feel, I hope that there is something in this book to suit your taste. Glass paints work well not only on glass, but also on acetate and plastic. Here I show you how to use them to decorate vases, bottles, wine glasses, a mirror, clip frames, plastic baubles and panels and also to make cards, fridge magnets and even mad fairies! Use it as a recipe book for inspiration and fun. Enjoy the feast!

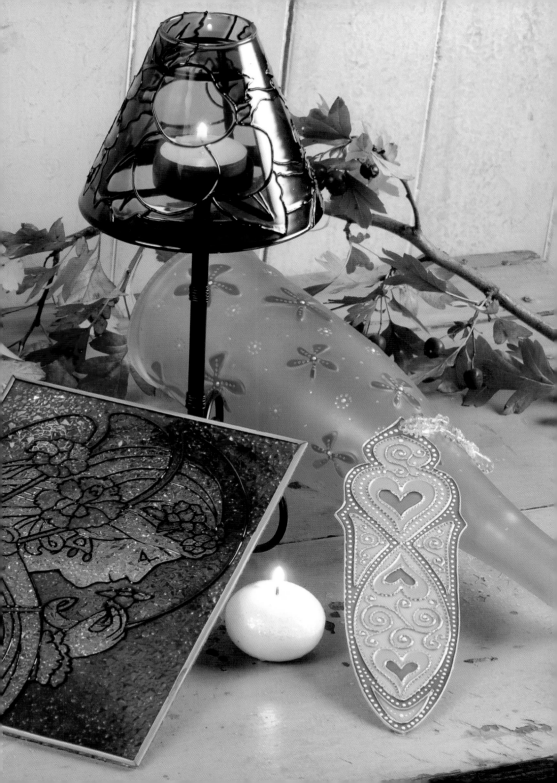

Materials and techniques

Outliner

Outliner is supplied in tubes, and comes in many colours (plus a metallic range). It is piped on to the surface through a fine nozzle. The aim is to achieve an even, raised line, with no gaps for the paint to seep through. If you have not used outliner before, try practising on paper before you work on glass. Keep the nozzle clean when working to prevent a build-up of paste on the nozzle.

It is easier to outline the design with black outliner, as glass paints colour the metallic types. Gold and silver detailing can be added after painting.

Glass paint

Apply glass paint generously to the outlined sections allowing it to float and settle to achieve a flat glass-like surface. Using too little paint will mean that brush strokes will be visible. The glass paints used in this book can be divided into two categories: water-based and Vitrail (solvent-based) glass paints.

Water-based glass paints

Bakeable water-based glass paints are versatile. They dry quickly and have very little smell. An item decorated with these paints will have a bright modern feel.

They are designed to be used on glass to give a durable and dishwasher-safe finish. The painted item is 'baked' in a domestic oven according to the manufacturer's instructions. This is ideal for using on any item that will come in contact with food or drink.

Make sure you use the correct bakeable outliner with these paints if you are going to bake an item. These paints can also be used on acetate and will air dry perfectly.

Vitrail (solvent-based) glass paints

Vitrail glass paints flow wonderfully on to glass. Items decorated with these paints have a more 'aged' look to them. They take time to dry and work should be done in a well-ventilated area.

White glass paint

White glass paint is the only opaque paint in the range, and it can be mixed with the coloured glass paints to achieve a range of opaque colours.

Lightening medium

In each manufacturer's range of glass paints, you will find a clear glass paint which can be used to dilute the paints to achieve pastel hues. This is very useful as the paints can appear a little dark when used straight from the bottle, especially when working on acetate for card-making.

Mix the lightening medium and glass paint in a palette gently to avoid creating air bubbles.

A detail from the Sophisticated Shoe Card on page 28, illustrating the use of black outliner and various water-based glass paints.

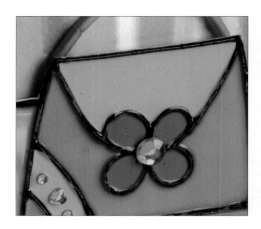

Techniques

Sponging

Pour a little glass paint into a palette. Create a small 'pad' from a piece of sponge and dab the surface. Continue dabbing, working over the glass until the air bubbles start to disperse and the surface becomes even. The bottle on page 34 is decorated with this technique.

Dribbling

The cocktail glass on page 44 is dribbled with paint. The paint is thinned with the same amount of diluent to allow the paints to flow easily.

The diluent is sold along with the same range of paints in most art and craft shops.

Freehand painting

A soft, synthetic paintbrush is used with a one-stroke technique to decorate the Sweet Heart project on page 42. Load the brush with paint before painting each flower petal.

Flower Fridge Magnet

Materials:

Two 9cm (3½in) square pieces of acetate
Black outliner
Matt glass paints: mauve and azure blue
Pink button
12mm (½in) diameter round fridge magnet

Tools:

Paintbrush
Scissors
Glue
Double-sided sticky pad

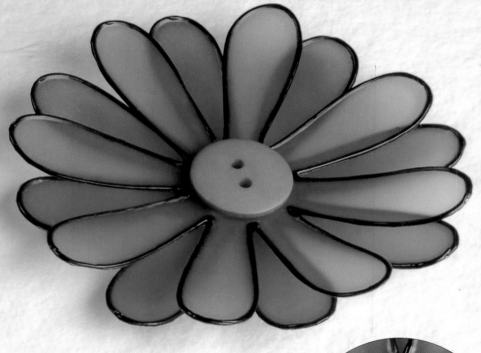

Instructions:

1 Place the piece of acetate over the flower template, and use outliner to trace it. Repeat on the second piece of acetate.

2 When dry, paint one flower mauve and the other azure blue. Leave to dry and become frosted.

3 Cut out each flower, and mount the mauve flower on top of the azure blue flower with a sticky pad.

4 Glue a button to the flower centre (see detail opposite) and a magnet to the back.

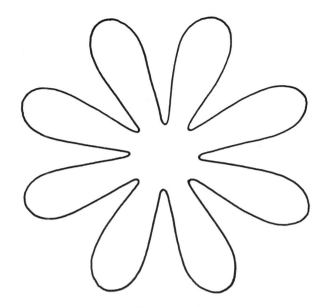

The Flower Fridge Magnet template, reproduced at the correct size.

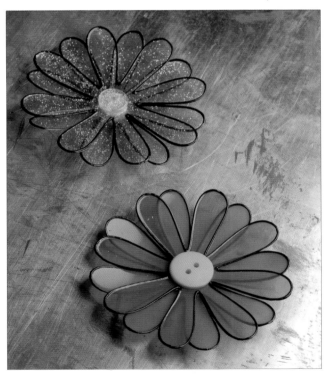

Flower Mad

Create a posy of fridge magnets using different coloured glass paints and buttons!

9

Cosy Cat Card

Materials:

Black base card, folded to measure 12.5 x 15.5cm (5 x 6⅛in)
Acetate, 12 x 15cm (4¾ x 6in)
White card, 12 x 15cm (4¾ x 6in)
Red corrugated card, 12 x 15cm (4¾ x 6in)
Black, white and orange outliners
Gloss glass paints: pepper red, paprika and sun yellow
Matt glass paints: aniseed green and azure blue

Tools:

Masking tape
Paintbrush
Spray glue
Scissors
Ruler

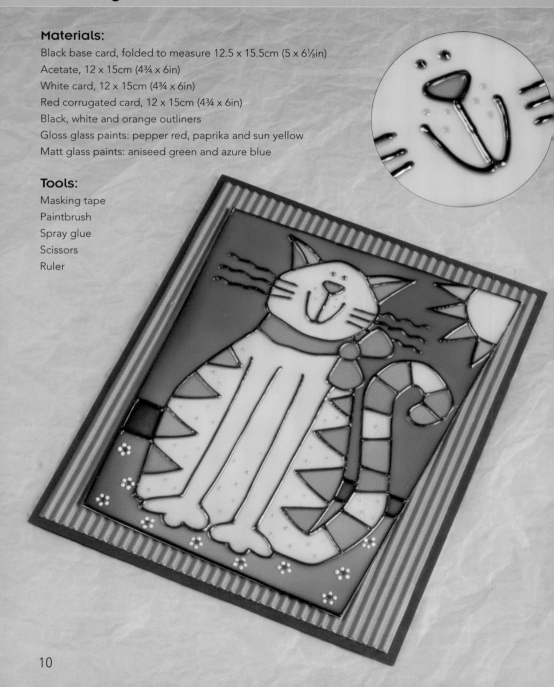

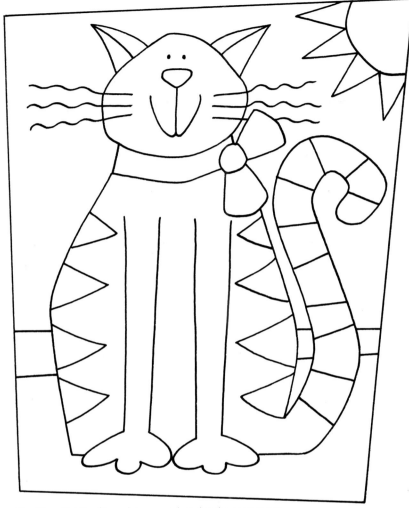

The Cosy Cat Card template, reproduced at the correct size.

Instructions:

1 Tape the acetate over the pattern and outline with black outliner.

2 When dry, paint the cat with gloss glass paints (see detail opposite) and the background areas with frosted glass paints. Leave to dry.

3 Pipe small spots of orange outliner on to the cat body. Create the daisies by piping small dotted circles with the white outliner, adding a dot of orange outliner to each daisy centre. Leave to dry.

4 Cut out the acetate cat design, spray the back with glue and press it on to white card.

5 Cut it out and mount it on to a 12 x 15cm (4¾ x 6in) piece of red corrugated card. Glue it to the front of the black base card.

Butterfly Wine Glass

Materials:
Wine glass with frosted stem
Water-based black and turquoise bakeable outliners
Water-based glass paints: Bengal pink and paprika

Tools:
Masking tape
Paintbrush

Instructions:

1 Photocopy the butterfly pattern four times, then cut out each one and tape them to the inside of the wine glass.

2 Outline the butterflies and leave to dry.

3 Paint the butterflies' wings with Bengal pink and their bodies in paprika (see detail).

4 When dry, decorate the glasses with dots of turquoise outliner.

5 Leave the glass to dry for twenty-four hours before baking in a domestic oven according to the manufacturer's instructions.

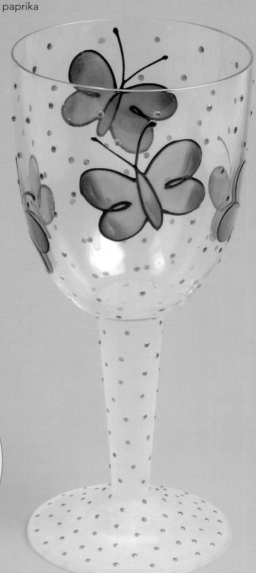

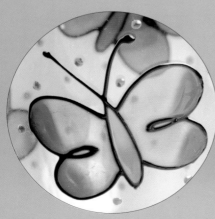

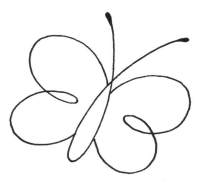

*The Butterfly Wine Glass template,
reproduced at the correct size.*

*The Funky Flowers template,
reproduced at the correct size.*

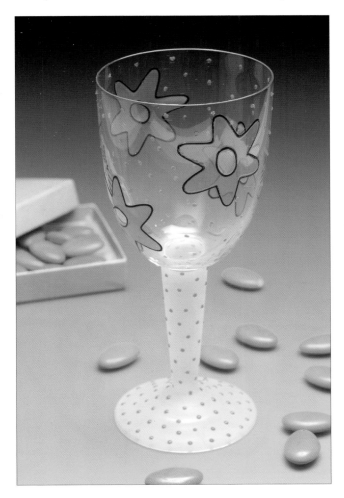

Funky Flowers

*Here, the glass is decorated with
vibrant flowers and dotted with
orange outliner.*

Mirror Candle Stand

Materials:

20cm (7⅞in) diameter mirror

Black outliner

Vitrail glass paints: lemon, orange, rose pink,
 emerald, greengold, deep blue and turquoise

Vitrail lightening medium

Carbon paper

Candle

Tools:

Masking tape

Paintbrush

Pencil

Palette

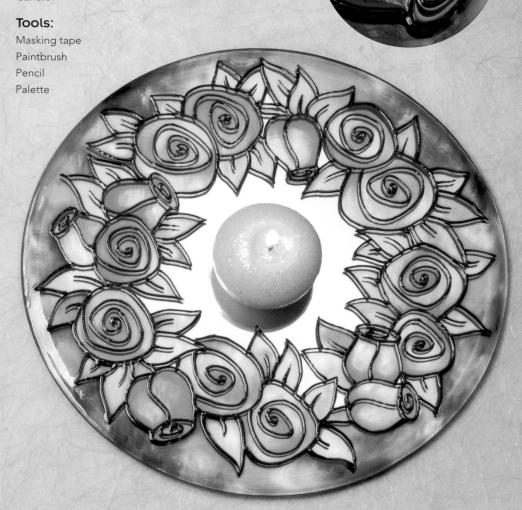

Instructions:

1 Photocopy the pattern at 200 per cent, cut it out and tape one end of it to the mirror.

2 Lift the pattern and slip the carbon paper underneath, face-down. Tape the pattern in place to secure it.

3 Use a pencil to trace over the design, transferring it to the mirror.

4 Outline the design with black outliner and leave to dry.

5 Pour a little lightening medium into a palette.

6 Paint the roses one at a time using the lemon, orange and rose pink paints, swirling spots of lightening medium into the wet paint as you work to achieve a mottled appearance (see detail opposite).

7 Next paint the leaves using the emerald and greengold paints. Add lightening medium as you work.

8 Fill in the outer areas with deep blue and turquoise glass paints, adding lightening medium as you work. Leave to dry. Stand your candle in the centre of the finished mirror.

The Mirror Candle Stand template, reproduced at half of the correct size. You will need to photocopy this at 200 per cent for the correct size.

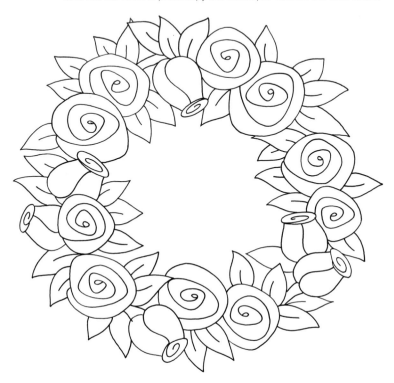

Purrfect Love Picture

Tools:
Masking tape
Paintbrush
Palette

Materials:
16cm (6¼in) square clip frame
Black and gold outliners
Vitrail glass paints: lemon, rose
pink, turquoise and parma
Vitrail lightening medium
16cm (6¼in) square of silver
holographic card

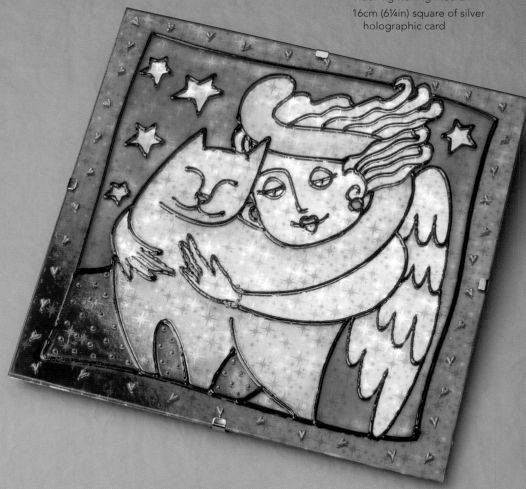

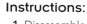

Instructions:

1 Disassemble the clip frame and tape the glass over the pattern.

2 Outline the pattern with black outliner. Leave to dry.

3 Paint the sections using lightening medium mixed with the coloured glass paints to create the more pastel areas.

4 When dry, pipe small gold outliner spots on to the dress (see detail) and add a bracelet of gold spots.

5 Pipe small outliner hearts around the border.

6 Place the square of holographic card behind the painted glass and reassemble the clip frame.

The Purrfect Love Picture template, reproduced at three-quarters of the correct size. You will need to photocopy this at 133 per cent for the correct size.

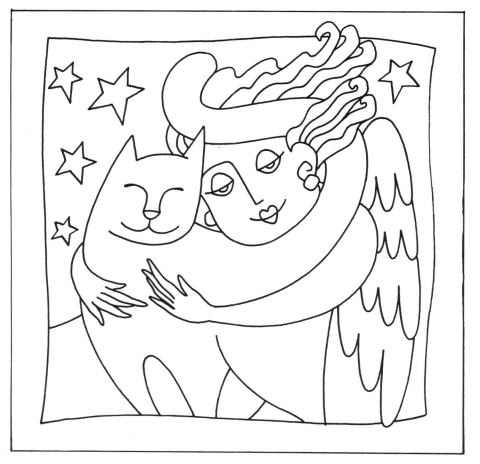

Mad Fairy Hanger

Materials:

Acetate, 10 x 12cm (4 x 4¾in)

Black and silver outliners

Glass paints: pepper red, Bengal pink and paprika

Clear glass painting gloss medium

Iridescent medium

Fine glitter

Pink fusible fibres

Gems

Red wire

Red glittery thread

Tools:

Tape

Scissors

Glue

Hole punch

Paintbrush

Palette

Instructions:

1 Use black outliner to trace the fairy design and shoes on to acetate. When dry paint the dress and shoes using paints straight from the pot.

2 Mix a spot of Bengal pink with some clear gloss medium in a palette to create a pastel pink shade. Paint the arms and the face.

3 Paint the wings with iridescent medium and sprinkle them with glitter while the paint is still wet. When dry, cut out the fairy and decorate the dress with spots of silver outliner and gems.

4 Punch one hole in the top of the head, two holes along the hem of the dress and a hole in the top of each shoe. Spiral two lengths of wire round the end of a paintbrush and loop one wire through each hem hole, twisting the wire to secure. Attach a shoe to each wire end.

5 Glue a clump of fusible fibres to the top of the fairy's head. Glue three gems along the hairline to cover the join (see detail).

6 Tie a length of red glittery thread through the hole in the top of the head.

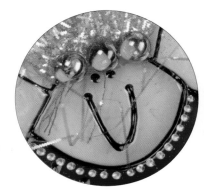

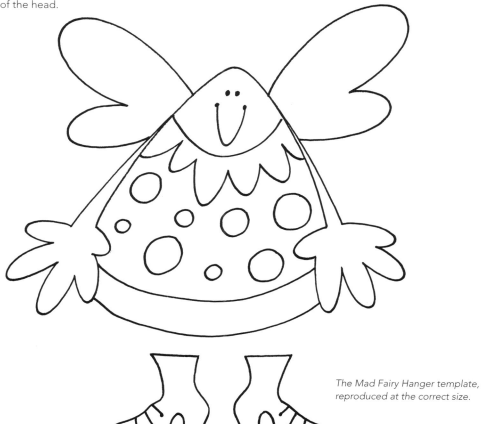

The Mad Fairy Hanger template, reproduced at the correct size.

Celtic Dragon Picture

Materials:

Picture frame with an aperture
 measuring 12 x 17cm (4¾ x 6¾in)

Black and gold outliners

Vitrail glass paints: lemon, orange
 and rose

Vitrail lightening medium

Rainbow paper

Tools:

Masking tape

Paintbrush

Palette

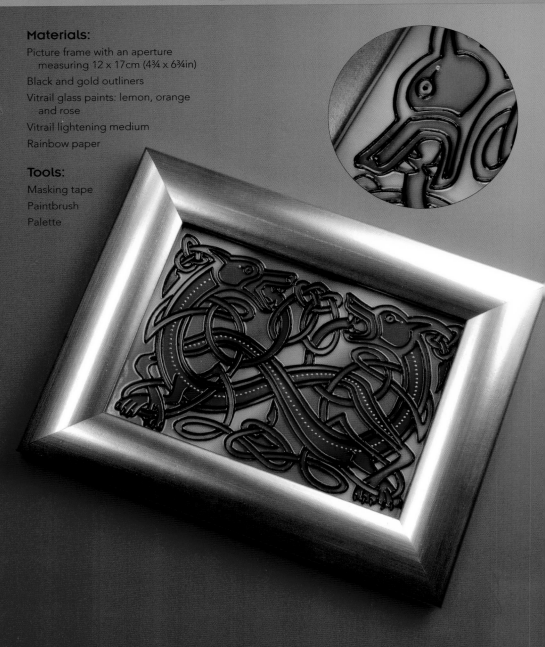

Instructions:

1 Disassemble the picture frame and tape the glass over the pattern.

2 Outline the design with black outliner and leave to dry (see detail opposite).

3 Fill in the dragon motifs using the lemon, orange and rose glass paints.

4 Mix a little orange paint with lightening medium in a palette to achieve a pale orange. Fill in the background areas and leave to dry.

5 Decorate the dragon with spots of gold outliner.

6 When dry, back the glass with a piece of rainbow paper cut to the same size. Reassemble the frame!

The Celtic Dragon Picture template, reproduced at three-quarters of the correct size. You will need to photocopy this at 133 per cent for the correct size.

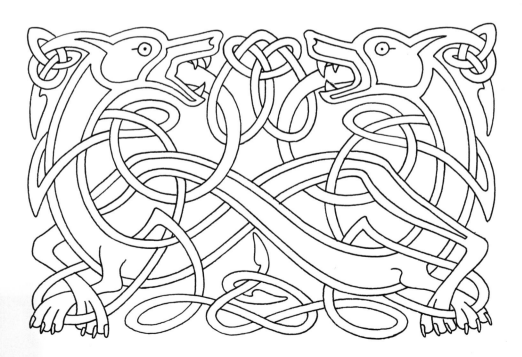

Flower Card

Materials:

White base card folded to measure 12 x 15cm (4¾ x 6in)

White card, two 8cm (3⅛in) squares

Spotted background paper, 10.5 x 13.5cm (4⅛ x 5⅜in)

Two pieces of acetate, each 8cm (3⅛in) square

Black and white outliners

Water-based glass paints: lazuli and veil white

Two mirror discs, each 1.5cm (½in) in diameter

Double-sided sticky pads

White ribbon

Blue wire

Tools:

Masking tape

Paintbrush

Scissors

Spray glue

Glue

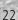

22

Instructions:

1 Glue the spotted background paper to the base card.

2 Outline the flowers on to acetate with black outliner.

3 When dry, paint the flowers with blue glass paint. While still wet, trail a wiggly line of white paint from the flower centre out towards each petal (see detail opposite). Leave to dry.

4 Glue a mirror disc to the centre of each flower and dot with white outliner. Leave to dry.

5 Spray the back of the flowers with spray glue and press them on to white card. Cut them out.

6 Attach sticky pads to the back of the flowers trapping a length of wire to each for the stem.

7 Press the flowers on to the base card and glue a ribbon bow over the wire stems.

The Flower Card template, reproduced at the correct size.

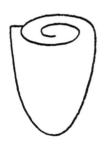

The In the Pink template, reproduced at the correct size.

In the Pink

These vibrant tulips are outlined, painted with pink glass paints and trailed with a lighter pink while still wet. Mounted on to green handmade paper and decorated with a heart mirror, they make the perfect posy.

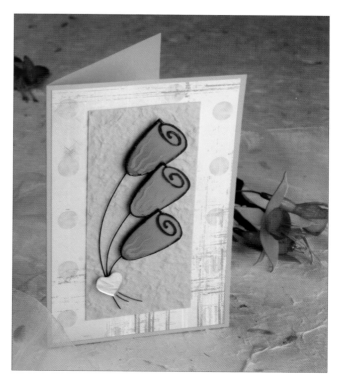

Fruity Lamp

Materials:

Lamp with glass shade

Black outliner

Vitrail glass paints: crimson, deep blue, orange and emerald

Tealight

Tools:

Masking tape

Paintbrush

Old cushion or towel

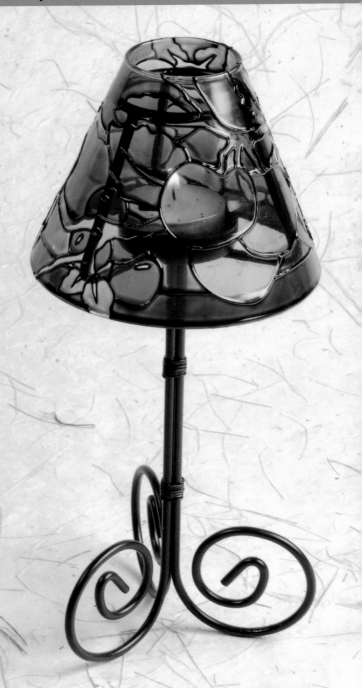

Instructions:

1 Place the pattern round the inside of the glass shape with the pattern showing through the glass. Tape it to secure.

2 Outline the design with black outliner and leave to dry (see detail).

3 Lay the shade on its side on an old cushion or towel. Paint approximately one third of the shade. Leave to dry before turning the shade round to paint the next third.

4 Repeat this again with the final third. Leave to dry.

5 Assemble your lamp and insert a tealight.

The Fruity Lamp template, reproduced at half of the correct size. You will need to photocopy this at 200 per cent for the correct size.

Fancy Bookmark

Materials:

Acetate, 7 x 20cm (2¾ x 7⅞in)

Gold and white outliners

Water-based glass paints: Bengal pink, emerald and cloud

Vitrail glass paints: old pink

Vitrail lightening medium

White card, 7 x 20cm (2¾ x 7⅞in)

Beaded tassel

Tools:

Masking tape

Paintbrush

Palette

Spray glue

Scissors

Hole punch

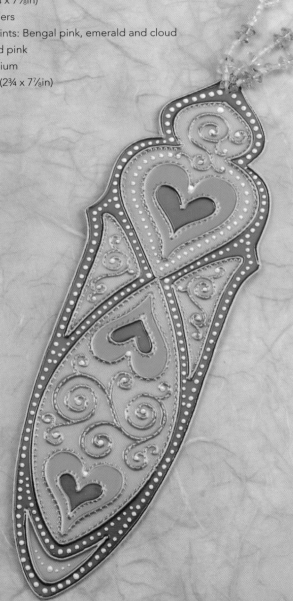

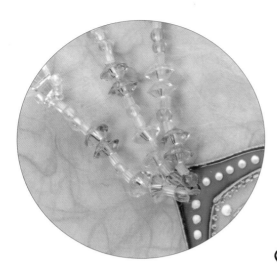

Instructions:

1 Tape the acetate over the pattern and outline with gold outliner.

2 When dry, paint the hearts with Bengal pink.

3 Use a palette to mix emerald and cloud to create a pale green and paint the areas around the hearts.

4 Use a palette to mix a little old pink with lightening medium and paint the remaining areas. Leave to dry.

5 Decorate the painted acetate design with dots of gold and white outliner and leave to dry.

6 Cut out the acetate bookmark, spray the back with spray glue and press it on to white card. Cut round the bookmark.

7 Punch a hole in the top and attach the tassel (see detail).

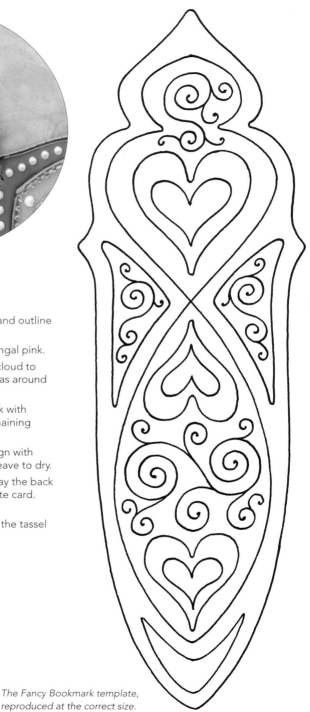

The Fancy Bookmark template, reproduced at the correct size.

Sophisticated Shoe Card

Materials:

Acetate

Black outliner

Water-based matt glass paints: rose pink, grenadine, parma and cloud

Water-based gloss glass paint: saffron yellow

White and coral coloured card

Striped background paper

Double-sided sticky pads

Bugle beads

Wire

Gems

Tools:

Masking tape

Paintbrush

Palette

Spray glue

Glue

Small scissors

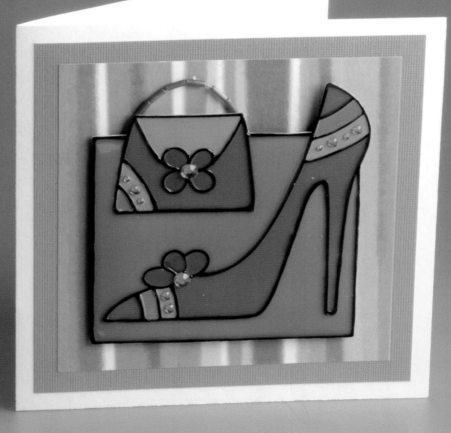

Instructions:

1 Glue an 11.5cm (4½in) square of coral coloured card on to a 13cm (5in) square white base card. Glue a 10cm (4in) square of striped paper on top.

2 Tape the acetate over the pattern and outline with black outliner. Leave to dry.

3 Fill in the shoe and handbag sections with the matt glass paints and the background with the gloss saffron yellow paint.

4 When dry, cut out the acetate design, spray the back with spray glue and press it on to white card. Cut out the mounted design.

5 Attach sticky pads to the back of the design and remove the backing papers.

6 Thread a few bugle beads on to a small length of wire and press the ends of the wire on to the sticky pads to create the handbag handle (see detail).

7 Decorate the shoe and handbag with gems.

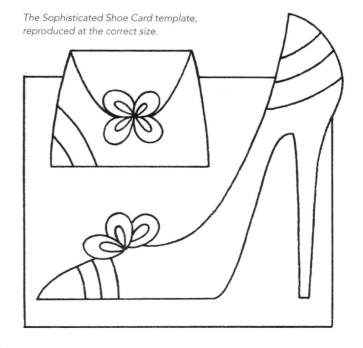

The Sophisticated Shoe Card template, reproduced at the correct size.

Art Nouveau Picture

Materials:

Textured plastic panel, 15 x 21cm (6 x 8¼in)

Self adhesive 2 x 3mm (1/12 x 1/8in) width lead strip

Black outliner

Vitrail glass paints: lemon, rose pink, red violet, dark green and parma

Vitrail lightening medium

Tools:

Masking tape

Paintbrush

Palette

Scalpel

Boning tool

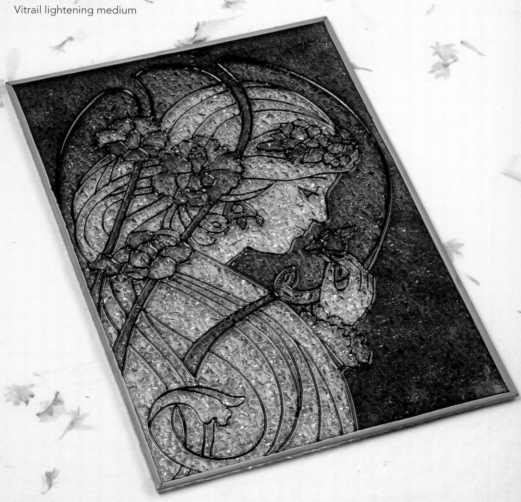

Instructions:

1 The lead strip is provided double ribbed. Cut two 23cm (9in) lengths and two 17cm (6¾in) lengths and cut them down the middle groove to give you four lengths.

2 Press the strips around the edge of the plastic panel and rub them firmly with the boning tool.

3 Use a scalpel to cut diagonally through each corner and remove the overhanging pieces to achieve neat, mitred corners (see detail).

4 Lay the panel over the pattern and outline with the black outliner.

5 Mix the glass paints with lightening medium in your palette to achieve the pastel colours.

6 Fill in the outlined areas with the diluted glass paints and leave to dry.

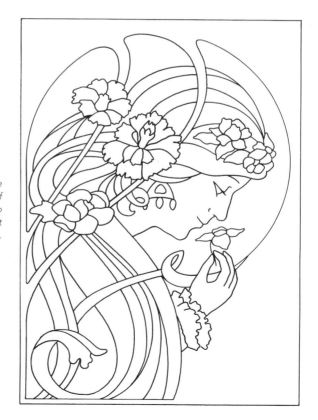

The Art Nouveau Picture template, reproduced at half of the correct size. You will need to photocopy this at 200 per cent for the correct size.

Heart Frame

Tools:

Masking tape
Paintbrush
Palette
PVA glue

Materials:

16cm (6¼in) square clip frame
Gold outliner
Vitrail glass paints: lemon, greengold, parma, red violet, rose and orange
Vitrail lightening medium
Assorted gems and small beads
White paper

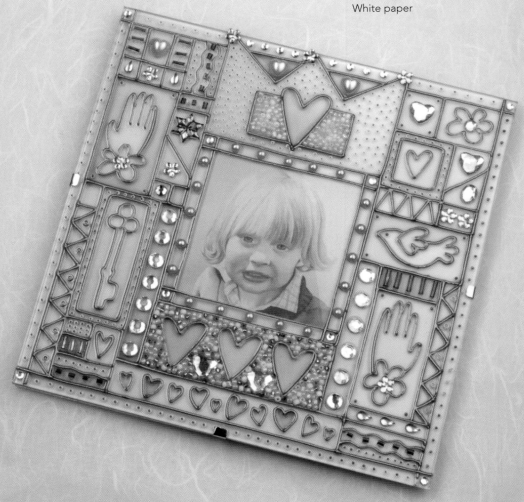

Instructions:

1 Disassemble the clip frame and tape the pattern to the underside of the glass.

2 Outline the design on to the glass with gold outliner.

3 Use a palette to mix the glass paints with lightening medium to create a range of pastel colours. Paint the sections and leave to dry.

4 Glue gems and beads into the sections (see detail).

5 Decorate the frame with dots of gold outliner and leave to dry.

6 Cut a 16cm (6¼in) square of white paper and glue your chosen photograph to the middle to fit within the aperture. Reassemble the frame.

The Heart Frame template, reproduced at three-quarters of the correct size. You will need to photocopy this at 133 per cent for the correct size.

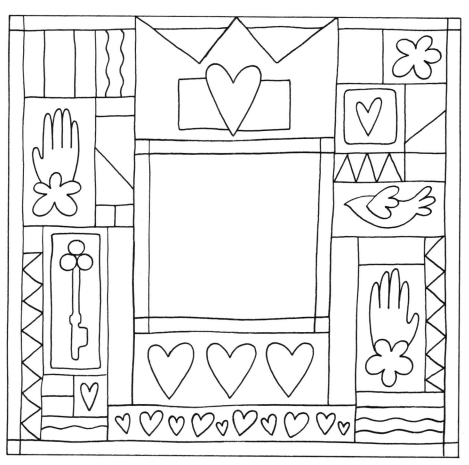

Pink Posy Bottle

Materials:

Clear glass bottle embossed
 with raised flowers
Frosted glass paint: grenadine
Clear frosted medium
Pearl and gold outliners

Tools:

Palette
Piece of sponge
Paintbrush

Instructions:

1 Pour some frosted medium on to a palette and mix in a few drops of the grenadine glass paint to create a pastel pink colour.

2 Holding the bottle at the top and starting at the bottom of the bottle, use a small piece of sponge to dab the paint on to the bottle. Leave to dry.

3 Use a paintbrush to paint the raised flowers with grenadine.

4 When dry, use the pearl and gold outliners to decorate the bottle (see detail opposite).

Blue Bouquet

Here, the same bottle is sponged with matt turquoise glass paint. The flowers are painted using gloss turquoise paint and dotted with gold and pearl outliners once dry.

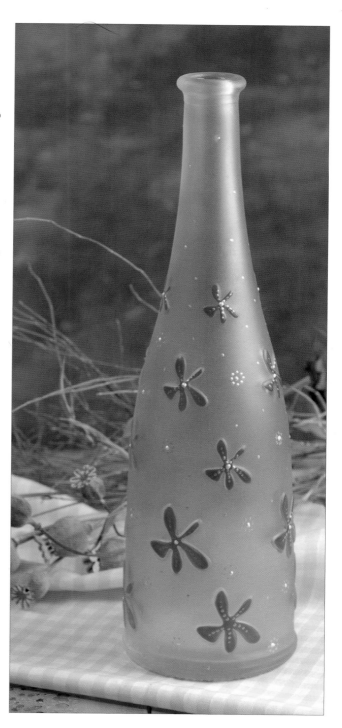

Cut-Glass Curiosity

Materials:

Old cut-glass vase

Water-based glass paints: red, Bengal pink, saffron

Self-adhesive pink gems (assorted sizes)

Tools:

Paintbrush

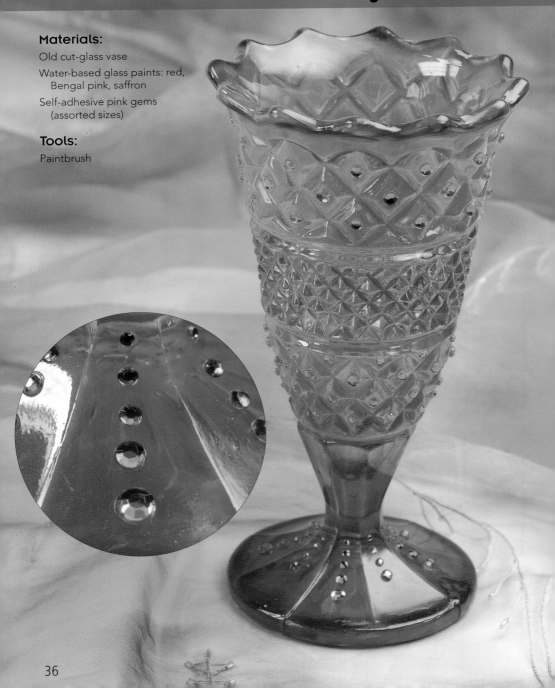

Instructions:

1 Starting at the top of the vase, use your paintbrush to apply bands of different coloured glass paints. Leave to dry before baking according to the manufacturer's directions.

2 Peel the gems from the backing sheet and press them on to the vase (see detail opposite).

Button Vase

This pretty cut-glass vase was painted with lilac and blue matt paints before being embellished with buttons and a matching ribbon.

Glitter Bauble

Materials:
Plastic bauble
Water-based iridescent medium
White outliner
Lilac glitter
Iridescent sequins
Ribbons
Violet shredded cellophane

Tools:
Piece of sponge
Glue

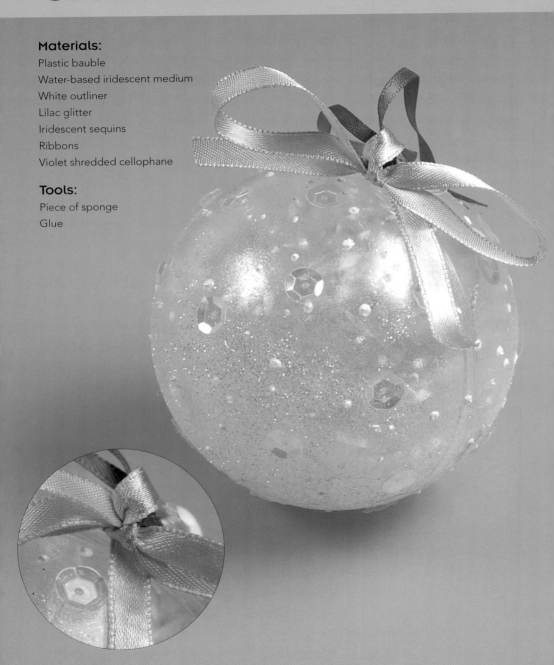

Instructions:

1 Open the bauble and pack with scrunched shredded cellophane. Close the bauble.

2 Sponge the bauble all over with iridescent medium and while still wet, sprinkle the lower half of the bauble with glitter.

3 When dry, glue sequins over the bauble.

4 Decorate with spots of white outliner and leave to dry.

5 Add a hanging ribbon and finally use a different ribbon to tie a bow round the base of the hanging ribbon (see detail opposite).

Festive Sparkle

Pink glitter and gems are used to decorate this plastic bauble. It is packed with pink fusible fibres for that extra festive glow.

Mosaic Vase

Materials:

Square glass vase.

Two 15cm (6in) squares of acetate

Water-based glass paints: Bengal pink and turquoise

Tools:

Paintbrush

Scalpel

Ruler

PVA glue

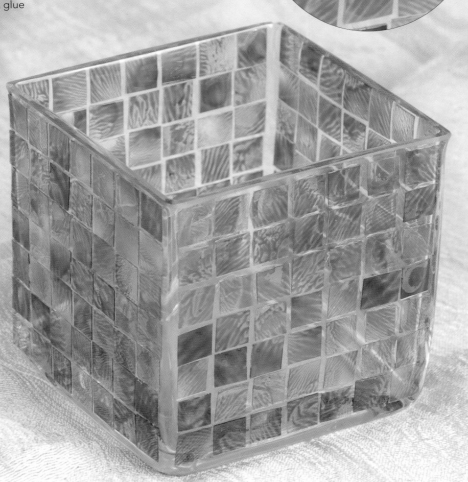

Instructions:

1 Using a paintbrush, daub one sheet of acetate generously with blobs of Bengal pink and turquoise paint.

2 While still wet, press the unpainted acetate square on top of the painted one, sandwiching the paint between the two sheets.

3 Press your fingers over the sheets to merge the paints together and then peel them apart and leave them to dry.

4 Use a scalpel and ruler to cut the coloured acetate into 1cm (½in) squares.

5 Glue the squares to the vase in a grid pattern (see detail opposite).

All Squared Up!

Red and yellow glass paints are used to paint the acetate sheets for this vibrant mosaic vase. It is then decorated with iridescent sequins and mirror heart embellishments.

Sweet Heart

Materials:

Heat-shaped hanging
 plastic bauble

Water-based matt glass
 paint: cloud (white)

Water-based gloss glass
 paints: Bengal pink,
 turquoise and emerald

Gold outliner

Ribbon

White tissue paper

Sweets or small gift

Tools:

Palette

Paintbrush

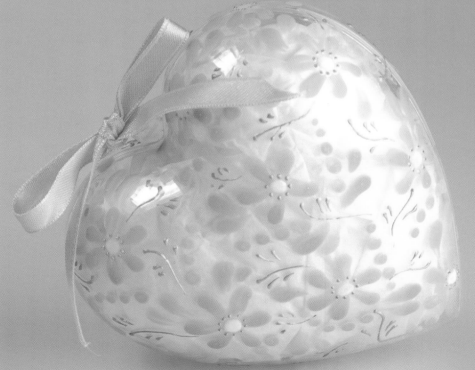

Instructions:

1 Use a palette to mix some white glass paint with each of the coloured paints to create pale pink, blue and green.

2 Paint one side of the heart with pale pink daisies adding rows of blue dots between the daisies and leave to dry.

3 Fill in any spaces with pale green leaves.

4 When dry, dot each flower centre with a blob of white paint.

5 Use the gold outliner to add a ring of dots around each flower centre, the stems and small fronds (see detail opposite).

6 Repeat this decoration for the other side of the heart.

7 Wrap some sweets or a small gift in white tissue paper. Open the heart, insert the gift and tie a ribbon bow to the hanging hole at the top of the heart.

Love Heart

This heart bauble is decorated with matt blue and white flowers and green leaves. Silver outliner is used to add the foliage fronds.

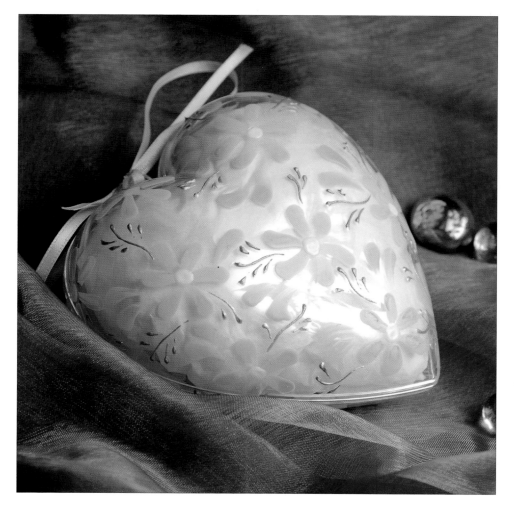

Dribbled Cocktail Glass

Materials:

Cocktail glass

Water-based bakeable glass paints: sun yellow, Bengal pink and emerald

Diluent

Tools:

Three small plastic applicator bottles with nozzles

Paper plate

Kitchen roll

Paintbrush

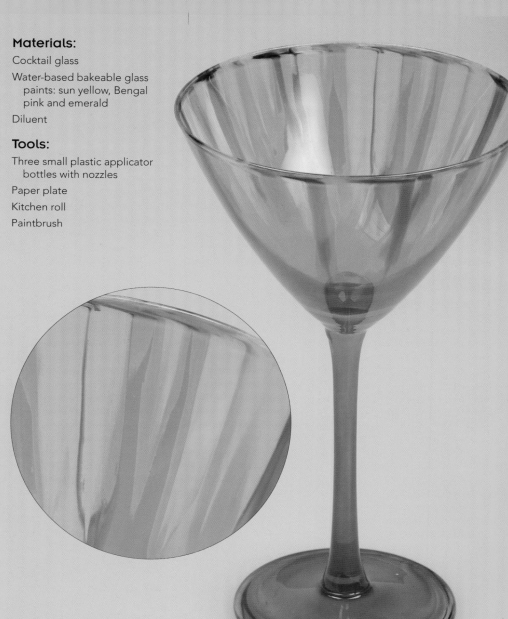

Instructions:

1 Pour a little of each coloured paint into applicator bottles, then add the same amount of diluent. Gently shake the bottle to mix the paint and diluent together.

2 Place the cocktail glass upside down on a paper plate. Starting at the base of the bowl of the glass, squeeze a ring of emerald paint round the glass so that it dribbles down the sides.

3 Now squeeze a ring of yellow paint below the pink paint. The paints will start to merge together as they run down the glass (see detail opposite).

4 The paints will gradually flow down and collect at the rim of the glass.

5 Lift the glass from the plate and roll the rim across some kitchen paper to soak up any excess paint. Keep doing this until the rim runs clean. Leave to dry.

6 Paint the stem with emerald paint and then use the applicator bottles to dribble the paints on to the base of the glass.

7 Leave to dry for 24 hours before baking in a domestic oven as described in the manufacturer's instructions.

Colourful Cocktail

This vibrant cocktail glass is dribbled with Bengal pink and emerald glass paints.

Encrusted Candle

Materials:

Glass candlestick

Turquoise water-based
 bakeable glass paint

Blue outliner

Assorted beads

Sequins

Buttons

Tools:

Small piece of sponge

Palette

Glue

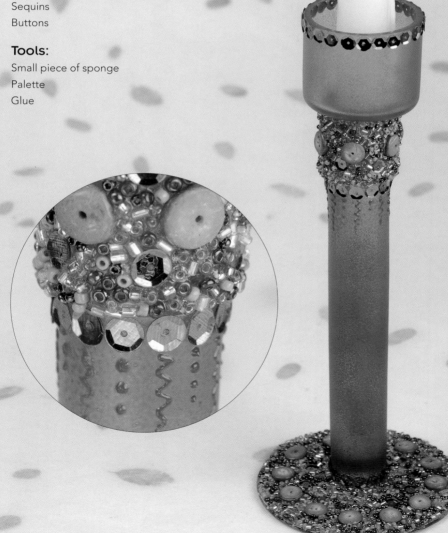

Instructions:

1 Pour a small pool of blue glass paint on to a palette and use the sponge to dab the paint over the candlestick until it is even. You do not have to apply paint to the areas to be decorated with beads, sequins and buttons.

2 Leave to dry and bake according to the manufacturer's instructions.

3 Working on a small area at a time, apply glue to the band near the top of the candlestick.

4 Press the buttons, sequins and beads into the glue and leave to dry (see detail opposite).

5 Repeat this process on the base of the candlestick and decorate in the same manner.

6 Glue a row of sequins round the top of the candlestick and above and below the encrusted areas.

7 Working just below the upper encrusted band, pipe squiggles and wavy lines of blue outliner.

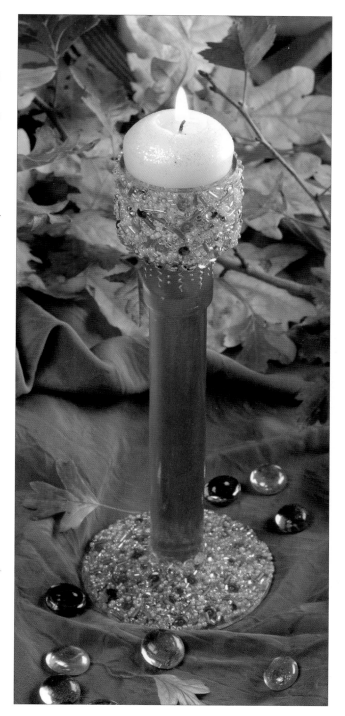

Rosy Glow
Pink gloss glass paint is sponged on to this candlestick before it is decorated with pink gems, beads, sequins and silver outliner.

Acknowledgements

Huge thanks to the wonderful Search Press team once more. In particular, Editorial Director Roz Dace for her constant support, Editor Edd Ralph for all his hard work, Debbie Patterson for her beautiful photography and Juan Hayward and Marrianne Mercer for their skilful design. A big thank you to John Wright and the team at Pebeo UK Ltd for providing all of the glass-painting materials featured in this book, and to Efco Hobby Products for providing many of the blanks used for decoration.

Publishers' Note

If you would like more books on the techniques shown, try the following:
Art Nouveau Glass Painting by Alan Gear and Barry Freestone, David & Charles 2008
Classic Glass Painting by Judy Balchin, Search Press 1999